Jewish Life in Poland

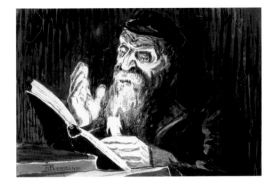

Reader, 1930. India Ink on Paper. 35 x 51 cm.

The Art of Moshe Rynecki (1881-1943)

Order this book online at www.trafford.com
or email orders@trafford.com

Most Trafford titles are also available at major online book retailers.

Print information available on the last page.

ISBN: 978-1-4120-7739-2 (sc)
ISBN: 978-1-4907-5493-2 (e)

Our mission is to efficiently provide the world's finest, most comprehensive book publishing service, enabling every author to experience success.
To find out how to publish your book, your way, and have it available worldwide, visit us online at www.trafford.com

Trafford rev. 05/22/2019

 www.trafford.com

North America & international
toll-free: 1 888 232 4444 (USA & Canada)
fax: 812 355 4082

In the Study, undated. Oil on Parchment. 23.8 x 43 cm.

Museum Holdings

Refugees, 9/25/1939. Watercolor Sketch. 42 x 57 cm. Collection of Yad Vashem.
This painting is included in the Yad Vashem gallery, "dedicated to the fate of Jews in Western Europe."
One of the rooms, "Between Walls and Fences: The Ghettos," displays the art that survived life in the ghetto. The painting, "Refugees," is included in that display. The work can be viewed in person at the museum in Jerusalem, or online at the "Between Walls and Fences: The Ghettos," gallery.

The Gift of Bread, 1919. Oil on Parchment. Framed - 86.995 x 31.75 cm.
Collection of the Judah L. Magnes Museum, Gift of George Rynecki.

The National Museum in Krakow has at least 22 paintings.
In a 1989 catalog titled, "Zydzi - Polscy. Muzeum Nardowe W Krakowie. Czerwiec - Sierpien 1989.
Wystawa Pod Protektoratem Ministra Kultury I Sztuki. Aleksandra Krawczuka," the catalog lists 22 of Moshe Rynecki's works.

Introduction

Moshe Rynecki used his paintbrush and palette to document and chronicle the life of his community - the Jewish people of Warsaw, Poland. Some artists, however, do more than simply document the subjects that they see and watch - they use the canvas to reveal something new - to show us that which we did not see at first, that which we might not consider if we had observed the subject ourselves. While some might have seen a group of men sitting at a table studying the Talmud, Rynecki reveals the Rabbi gesticulating as he talks, he shows the men's spines bent from spending so much time studying, he shows the tallit wrapped across the shoulders of those who have put their heads down for a brief rest, and he makes visible the light that gently streams into the darkened room.

Rynecki's drive and ambition to paint came early in life and it came from within. When he was five years old he used chalk and crude brushes to paint on the walls and floors of his parents' home. As he grew older, he always carried a sketchbook with him so that he could quickly draw that which caught his attention-people, their expressions, their hands.

While Rynecki spent much of his life painting the Jewish community, he also witnessed a great deal of change to his country, from the almost constant political turmoil that characterized Poland's brief independence between the World Wars, to the onset of Soviet aggression, and Nazi brutality at the start of the Second World War.

Rynecki, much to his son's dismay, willingly lived inside the walls of the Warsaw Ghetto. While his son warned him that the Nazi forces were not to be trusted, he only said, "If you are right my son, then let me go where my brothers and sisters go. And if it's death, so be it." Ultimately, Rynecki was deported to the Majdanek concentration camp where he perished.

Although the Holocaust brought great loss and ultimately a tragic end to Moshe Rynecki, the goal of this book is to celebrate his life and his work. To learn more about Moshe Rynecki and to see more of his paintings, please visit The Moshe Rynecki Virtual Museum at www.rynecki.org. To learn more about the Rynecki family, you may also want to read the memoir written by his son, George J. Rynecki, "Surviving Hitler in Poland: One Jew's Story."

Elizabeth Rynecki (Moshe Rynecki's great-granddaughter)
1 October 2005

On the cover: Krasinski Park, 1930. Oil on Cardboard. 33.5 x 49 cm.

Self-Portrait, 1936. China Ink and Wash. 31.5 x 48.8 cm

Bride and Self-Portrait, 1918. Watercolor and Pencil. 33 x 88 cm.

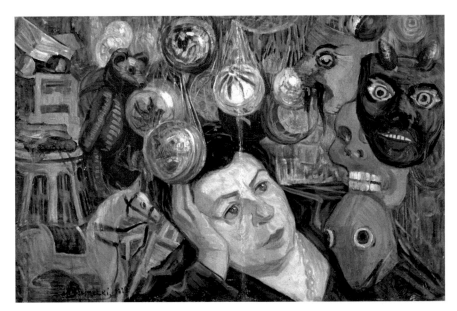

Paula Rynecki, 1929. Oil on Cardboard. 41 x 63 cm.

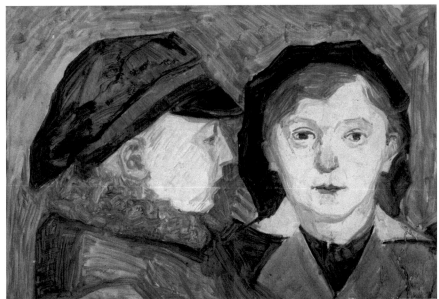

Rynecki Children, 1915. Oil on Cardboard. 32.1 x 48.2 cm.

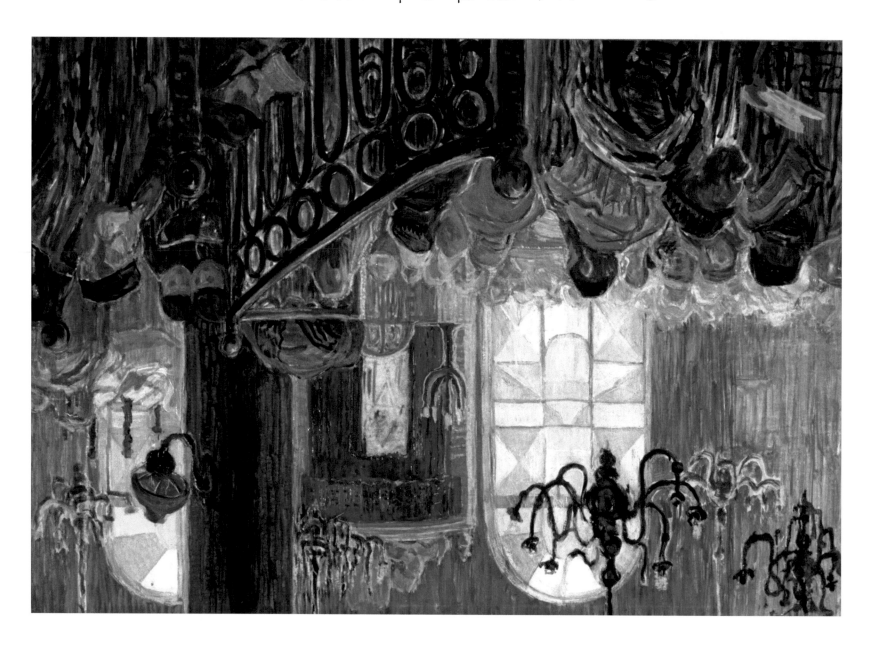

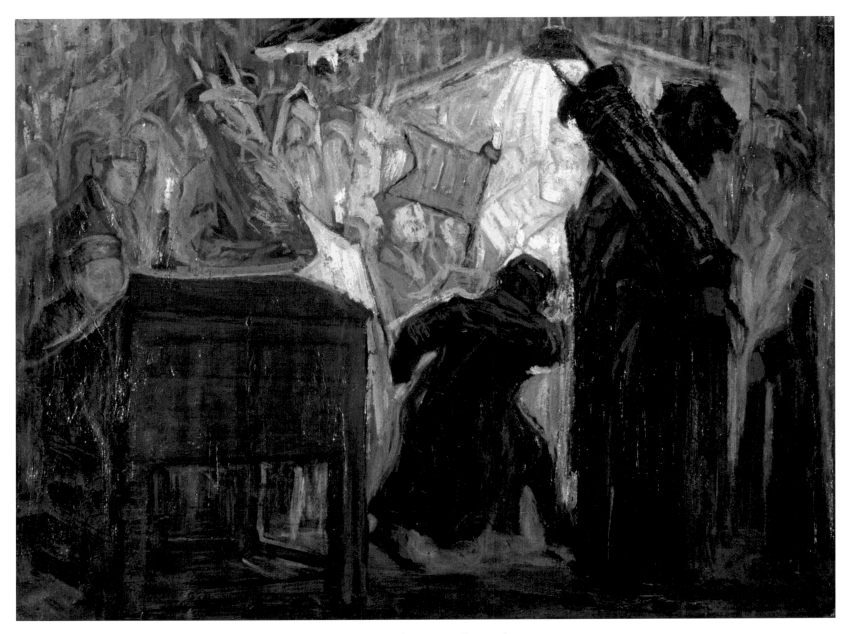

Simhat Torah, circa 1920. Oil on Cardboard. 33.5 x 46.3 cm.

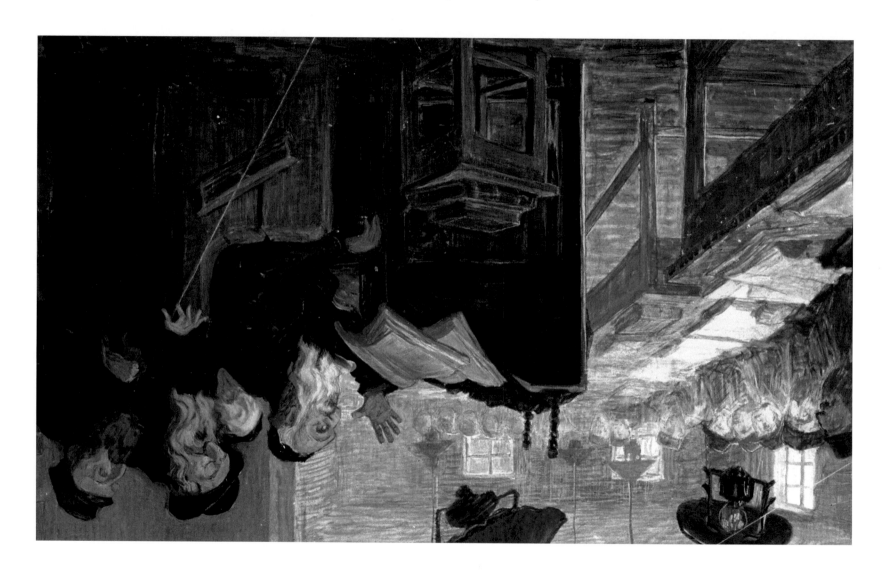

Teaching, 1928. Oil, 52 × 52 cm.

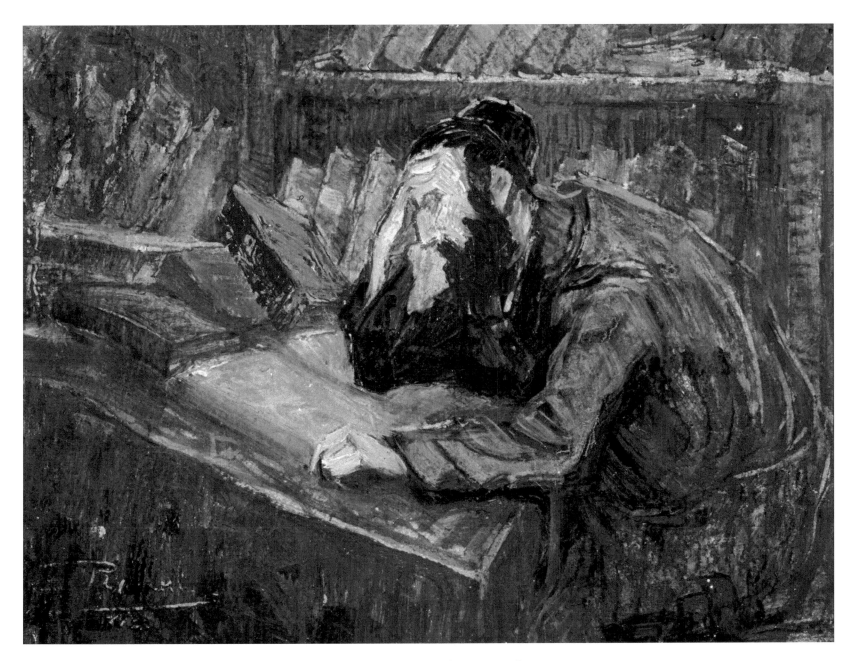

The Reader, undated. Oil on Board. 23 x 31 cm.

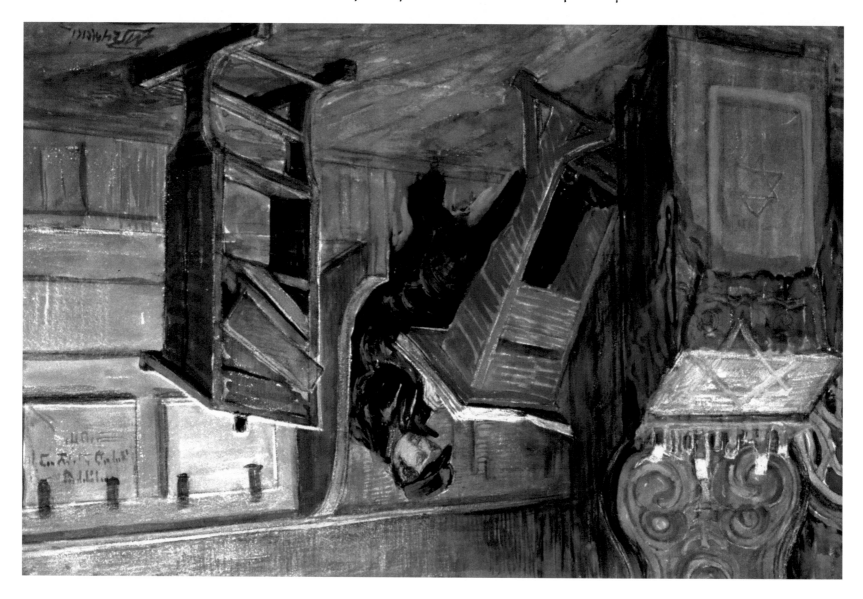

The Student, circa 1920. Watercolor and crayon, 33 x 49.5 cm.

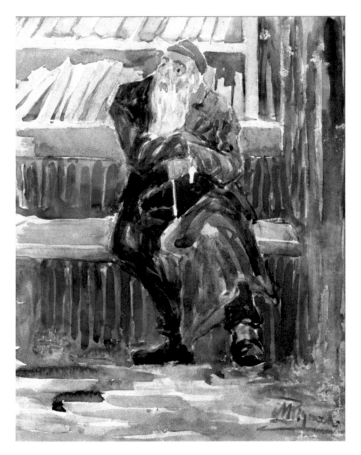

Old Jew, undated. Waterolor. 32 x 26 cm.

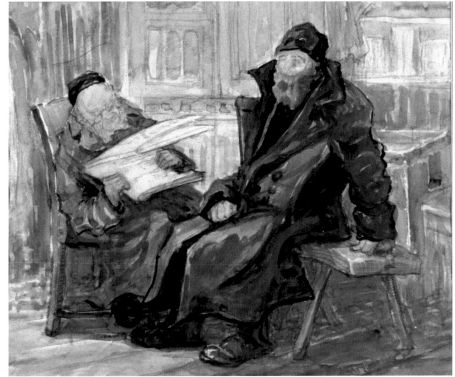

Reading the News, undated. Watercolor. 34 x 42 cm.

The Wedding (The First Dance), 1919. Oil on Parchment. 32.2 x 87.4 cm.

The Divorce (The Get), 1920. Watercolor. 35.3 x 56.5 cm.

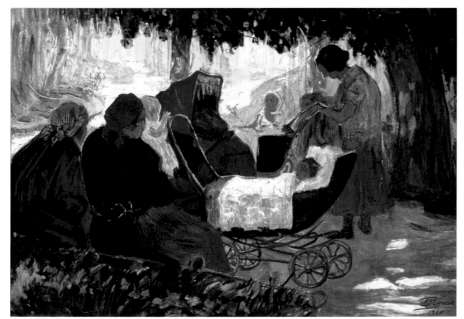

In the Park, 1930. Oil on Parchment. 34 x 49.3 cm.

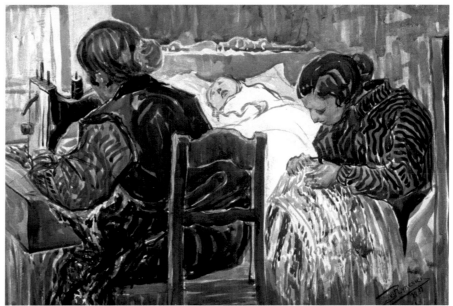

The Seamstresses, 1931. Watercolor on Paper. 32 x 48 cm.

Boy with Purple Hat, undated. Watercolor. 38 x 45 cm.

Girl, 1931. Watercolor. 39 x 42 cm.

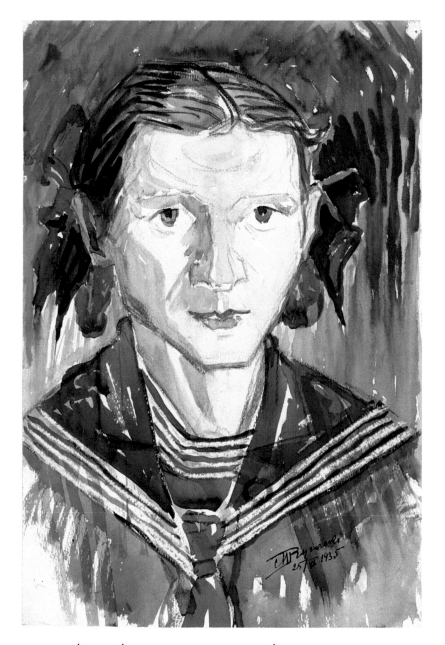

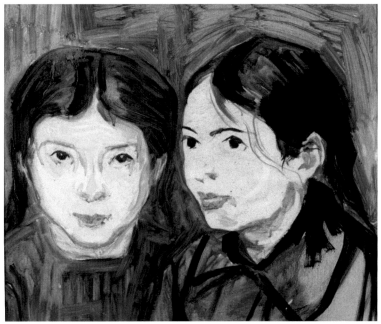

Neighborhood Children, undated. Watercolor. 32 x 38 cm.

Girl in Sailor Suit, 1935. Watercolor. 45 x 30 cm.

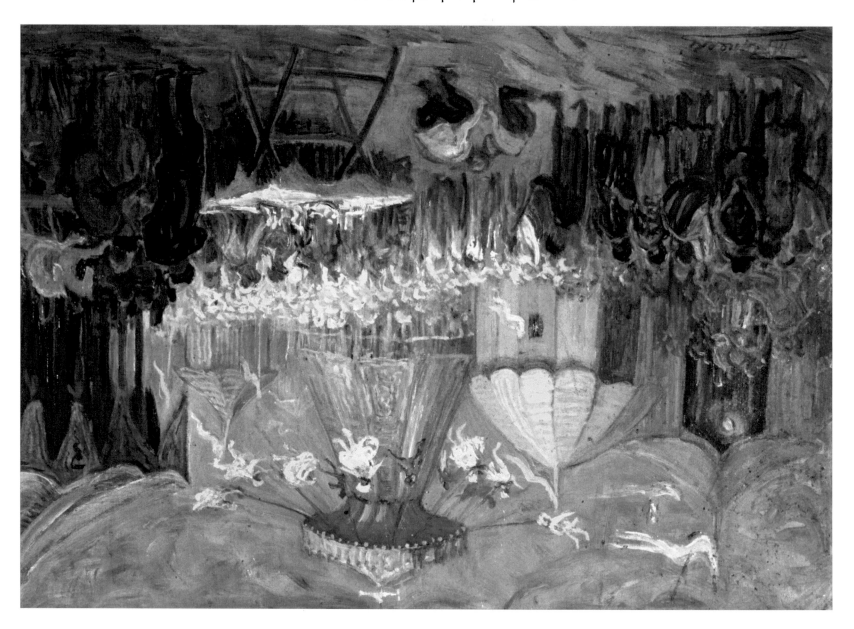

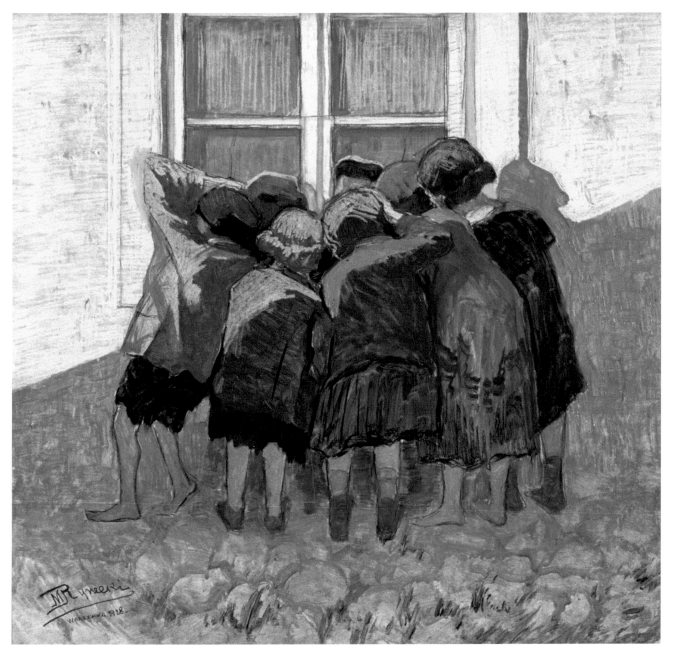

Curious Children, 1928. Oil on Parchment. 32.8 x 35.3 cm.

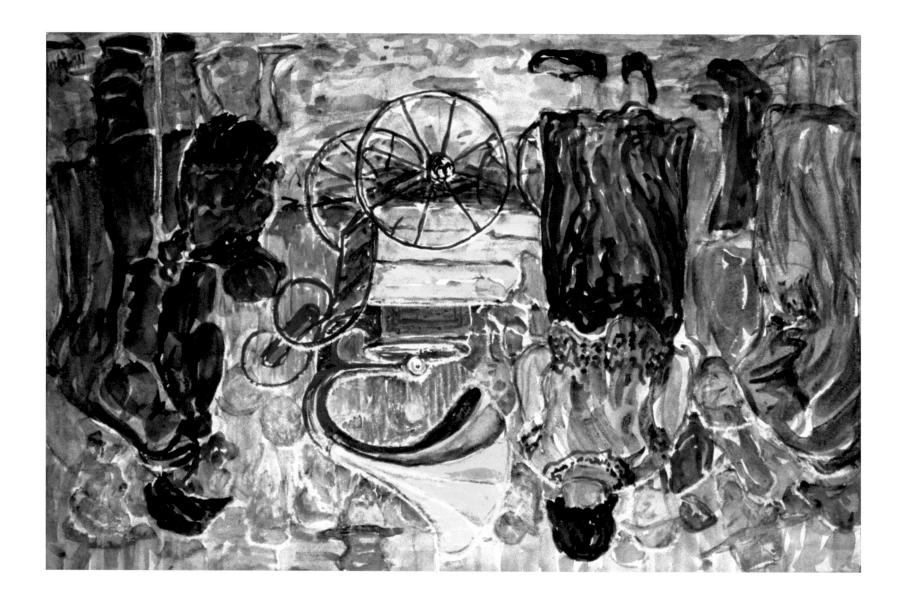

Gramophone Player, undated. Watercolor. 30 x 45 cm.

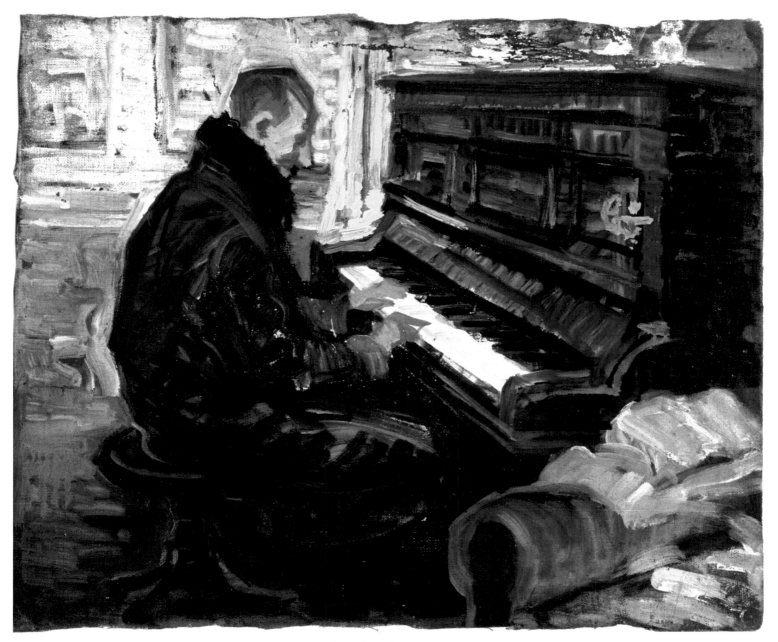

Pianist, undated. Oil on Canvas. 35.5 x 47 cm.

The Chess Players, 1935. Watercolor. 31.5 x 48.3 cm.

Chess Game, undated. Oil. 33 x 44 cm.

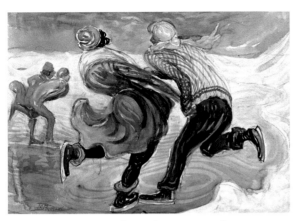

Ice Skaters, undated. Watercolor. 35 x 50 cm.

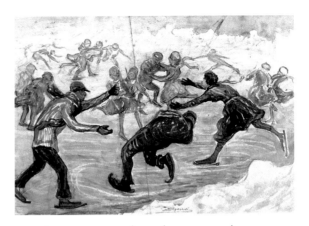

Ice Skaters II, undated. Watercolor. 35 x 50 cm.

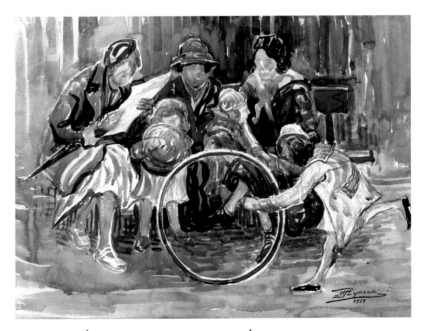

The Hoop, 1934. Watercolor. 35 x 47 cm.

Toy Factory, 1937. Watercolor. 33 x 50 cm.

Factory Floor, 1935. Watercolor. 32.5 x 50 cm.

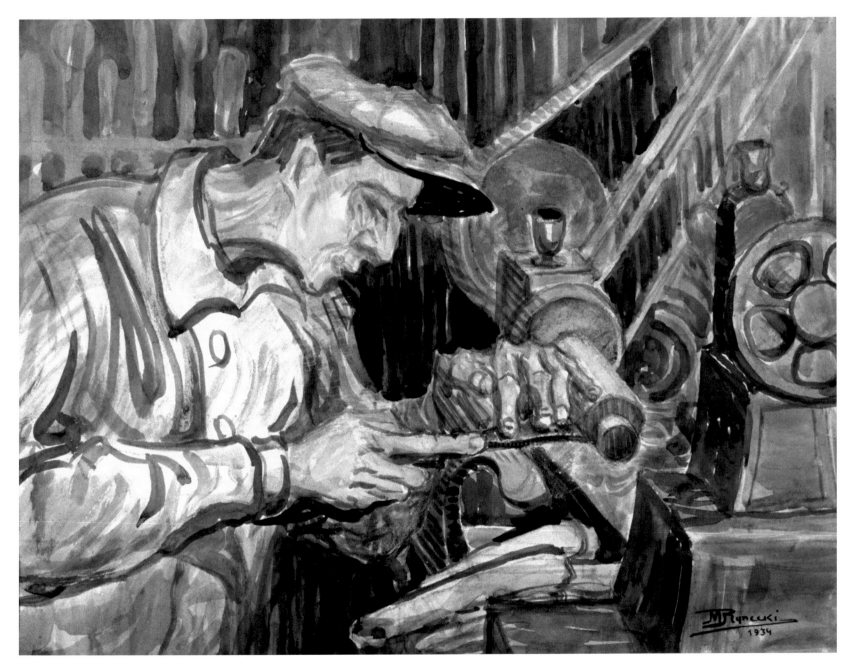

The Factory, 1934. Watercolor. 35.5 x 47 cm.

Water Carrier (The Wagon), 1937. Watercolor. 32 x 50 cm.

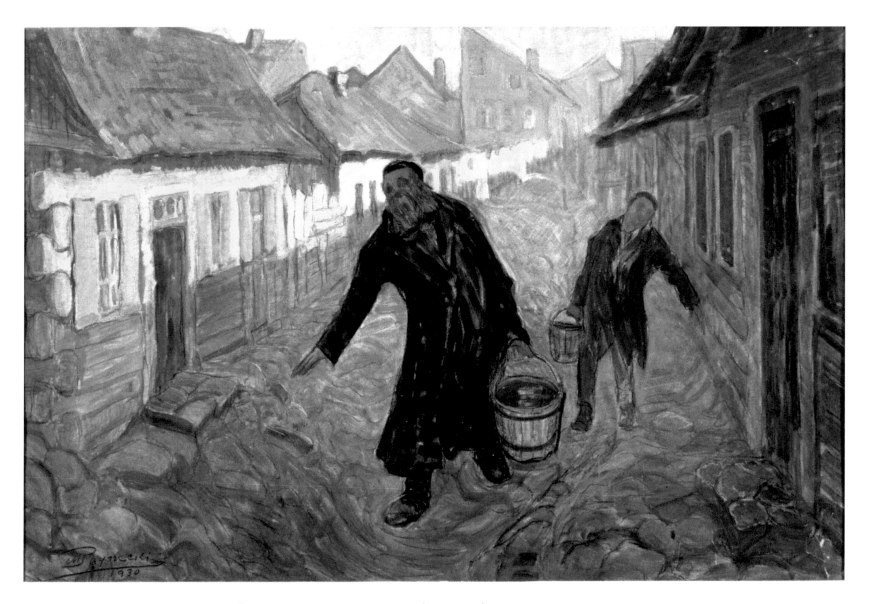

The Water Carriers, 1930. Oil on Parchment. 32 x 48.5 cm.

Forced Labor, 1939 (September 15). Watercolor Sketch. 45 x 55 cm.

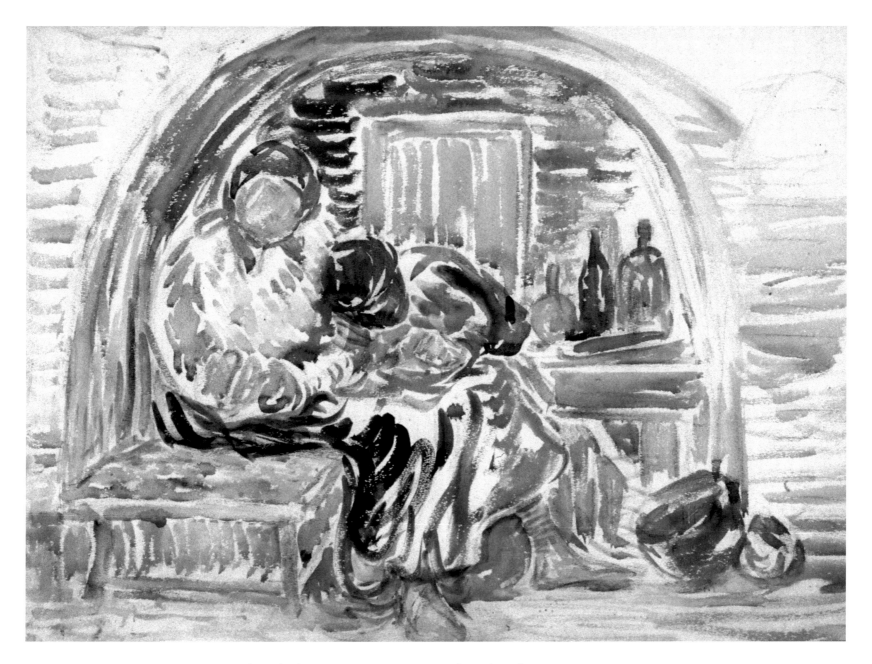

In the Shelter, circa 1939. Watercolor Sketch on Paper. 42 x 57 cm.

Men at Rest, undated. Watercolor. 33 x 50 cm.

Exhibitions

1928 Spring Salon of Jewish Art. Gallery at 6 Rymarska Street, Warsaw

1929 Society for the Advacement of Fine Arts. Warsaw.

1930 The 44th Annual Show of the Jewish Society for the Promotion of Fine Arts. 26 Dluga Street, Warsaw.

1930 Zacheta (Encouragement) gallery at Malachowski Square

1931 Zacheta

1932 Zacheta

1939 Fifth Jubilee Salon of Paintings and Sculpture Organization of Jewish Artists and Sculptors

November 8, 1981 – January 17, 1982
 The Judah L. Magnes Museum, Berkeley, California and the Women's Guild Fall Show.
 A Centennial showing of Moshe Rynecki's art. The exhibit was curated by Ruth Eis.

Printed in the United States
By Bookmasters